This book belongs to

ILLUMINATED LETTERS sketchbook

PETER PAUPER PRESS, INC.

WHITE PLAINS, NEW YORK

OUR COMPANY

In 1928, at the age of twenty-two, Peter Beilenson began print-ing books on a small press in the basement of his parents' home in Larchmont, New York. Peter—and later, his wife, Edna—sought to create fine books that sold at "prices even a pauper could afford."

Today, still family owned and operated, Peter Pauper Press continues to honor our founders' legacy—and our customers' expectations—of beauty, quality, and value.

Written and illustrated by Jane Sullivan, www.calligrafee.com

English adaptation by Jane Sullivan

English edition design by Margaret Rubiano

Published in the United States in 2016 by Peter Pauper Press, Inc.
202 Mamaroneck Avenue
White Plains, New York 10601
U.S.A.

Published in the United Kingdom and Europe by Peter Pauper Press, Inc.
c/o White Pebble International
Unit 2, Plot 11 Terminus Rd.
Chichester, West Sussex PO19 8TX, UK

ISBN 978-1-4413-1949-4
Manufactured for Peter Pauper Press, Inc.
Printed in China
7 6 5 4 3 2 1

Visit us at www.peterpauper.com

Originally published by Dessain et Tolra/Larousse 2014 as *Carnet de griffonnage: Lettres enluminées*
Copyright © May 2014
Editor: Corinne de Montalembert
Layout: Florence Le Maux
Original cover design: Véronique Laporte
Production: Jenny Vallée

Contents

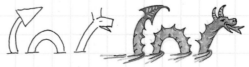

Illuminate your leisure moments with the pleasurable pastime of artistic writing! Draw, color, paint, and of course decorate an abecedary of beautiful letters. Bring to life a world of plants, animals, and intricate designs that dance around your letters: cats, butterflies, unicorns, and mermaids that fill the spaces of our medieval-styled alphabet. This art journal will guide you, whether your goal is to combat stress through creativity, learn the art of illumination, or simply take delight in beautiful writing and drawing.

The following pages provide full-color examples of letters, outlines for you to trace and color, tutorials for creating the details that make illuminated letters shine, and blank letter outlines for you to fill with your own illuminations. If you are creating your own outlines, use Chinese or India ink and a pointed nib, or a waterproof fine-line pen. For drawing in pencil, a B, 2B, or 3B lead is best, along with a good eraser.

To color your work you will need (depending on your preferences): colored pencils, fine-tip markers, and/or watercolor or gouache paints. If you work with paints, choose "artist quality" and use small pointed brushes. Add finishing touches to your designs in brilliant white paint. "Permanent white" gouache is indispensable for this!

Illuminations

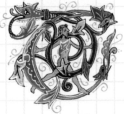

he ancient art of illuminating letters in the Western tradition can be traced back to religious manuscripts of the 5th century. It developed in complexity from the 7th century onward, and enjoyed its golden age from the 11th through 15th centuries, though works of surpassing beauty continued to be produced in the 16th century. After the invention of the printing press, the art of illuminated letters began to decline.

In sacred texts of the Middle Ages, illuminated letters were used to provide a vehicle for expressing the faith and fervor of monastic scribes, as well as adding color and beauty to a text. Besides their devotional and decorative uses, these beautiful letters served to separate verses of text, indicating by their size and color the importance of certain passages, psalms, or chapters of the Bible as well as other books, and helping the reader to navigate through manuscripts that normally bore no page numbers.

Throughout the history of calligraphy in Europe, different styles of illuminated letters have evolved to complement the scripts of various periods and places. The alphabet used in this book is often called "Lombard." Its forms are the most widespread and long-lived of the decorated letters found in medieval manuscripts, as it survived side-by-side with other styles from the earliest uncial codices right up to the late Gothic period.

The artist-illuminator must cultivate the talent of seeing several things at once: the overall form of an individual letter, the interior or "counter" space left free to decorate, the curves and movement of the lines, and even an arabesque or flourish that will complete or extend a part of the basic letterform.

On the next page you see an example of several Lombard letters. The term has no real relation to the region in northern Italy, but is a widely accepted name for this rounded style of capital letter. Pay attention to the parts of the letters that are fuller, as opposed to places where the lines are very thin—respectively the sides (wide) and the tops and bottoms (fine). And take the time to ensure that the interior spaces remain soft and fluid, with no sharp angles. The letters should be very upright and stable, and not lean to one side or the other.

When adding the second color for details superimposed on the first, white is the most traditional choice; however, a complementary color (yellow on purple, orange on blue, pale green on red) can work very well, as can a lighter shade of the letter's base color.

Decoration of a letter in watercolor or gouache paint:

1. Draw the outline of the letter in pencil, then retrace the same lines in ink if you wish. Erase any pencil lines that still show after the ink dries.
2. Paint the letter in one solid color, and allow to dry.
3. With a very fine paintbrush and your white or contrasting color of gouache, add delicate details or motifs on top of the first color.

If you work in colored pencil or marker:

1. As above, draw the letter in pencil, trace it in ink, and erase stray pencil lines.
2. Using your base color marker or pencil, draw the outlines of detailed decorations and motifs in the letterform. You'll leave these spaces blank when you color in the letter. (If you want to use a secondary color other than white, draw and fill in details directly in that color.)
3. Fill in the remainder of the letter with your base color.

Once you've had some practice drawing illuminated letters in this book, try creating larger works in watercolor or gouache paint on watercolor paper or Bristol board.

When you're first learning illumination, try copying or even tracing some of the most standard motifs and flourishes: little heart-shaped or triple leaves, regular loops and circles, lozenge forms, and interlaced cords (see pages 30-31 and 40-41).

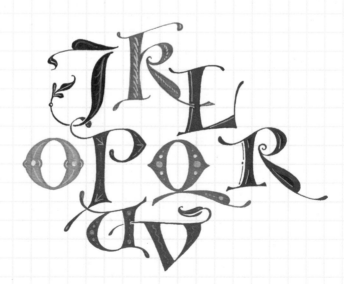

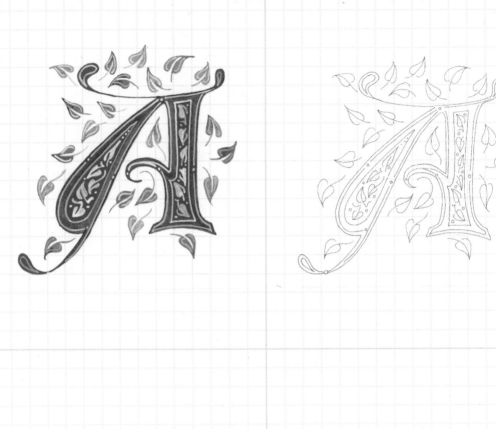

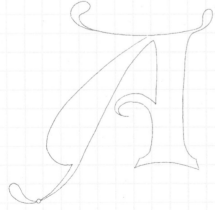

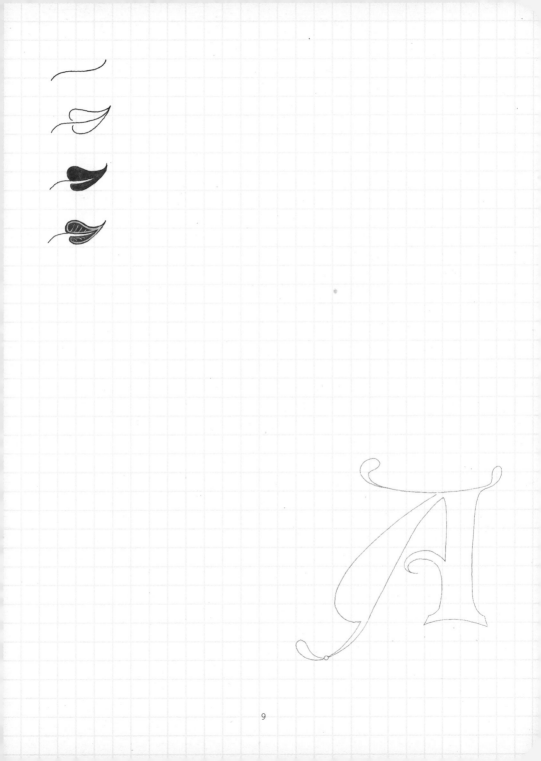

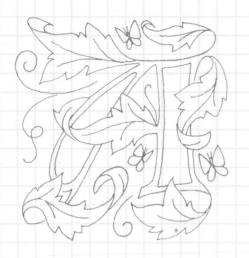

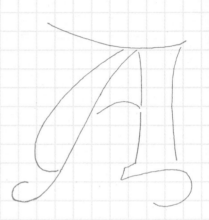

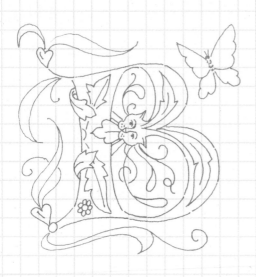

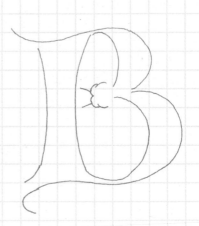

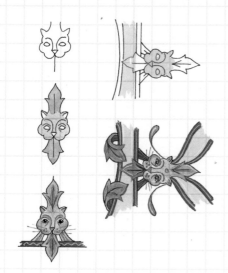

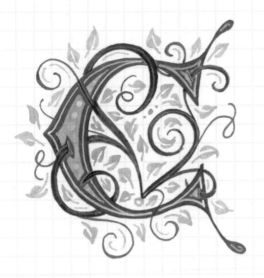

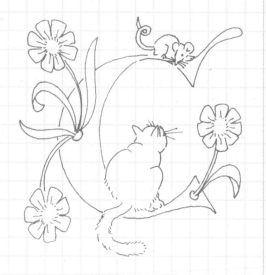

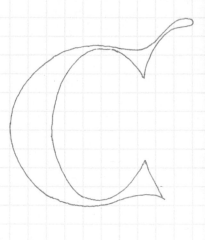

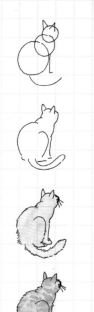

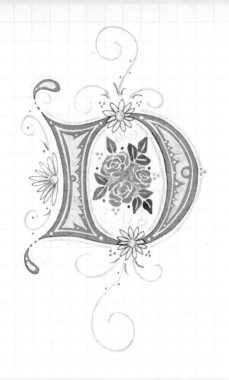

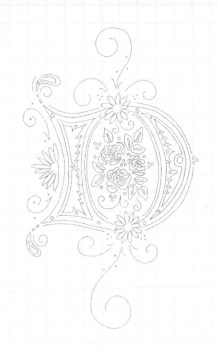

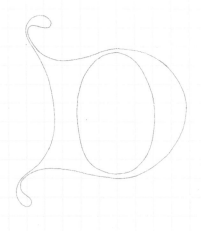

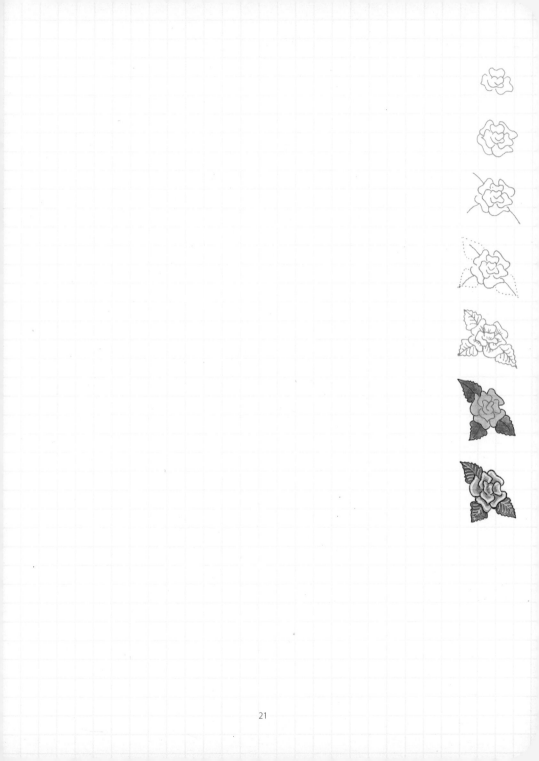

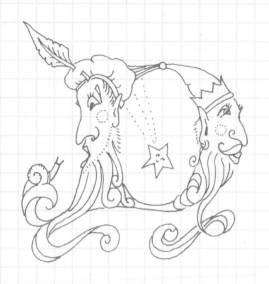

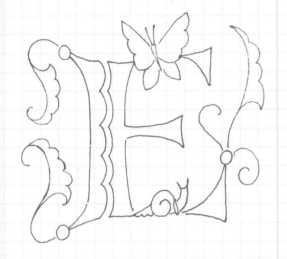

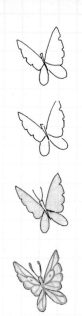

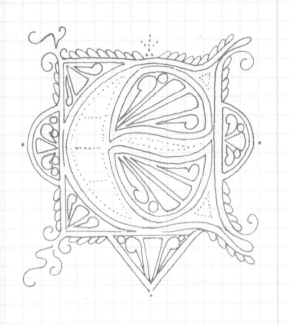

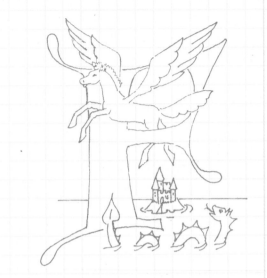

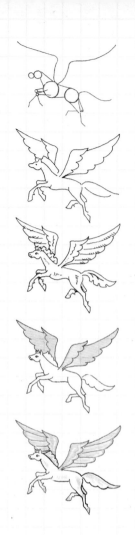

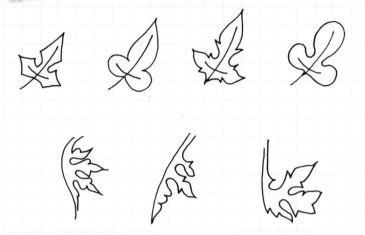

1. These leaves are not meant to be realistic! There is a whole repertoire of repeating leaf-forms in the manuscripts of the Middle Ages. Many are triple-pointed. Often the longer leaves, usually referred to under the general heading of "acanthus leaves," turn and twist, which gives them a slight sense of being three-dimensional. Copy these basic, common forms of leaves until you feel at ease to invent variations yourself.

2. When putting in place the underlying swirls and loops which will become your leaves, remember to keep them fluid with no sudden angles or corners. The direction of the loops should alternate: one loop clockwise, the next counter-clockwise, each growing out of the other with a harmonious sweep of the pencil!

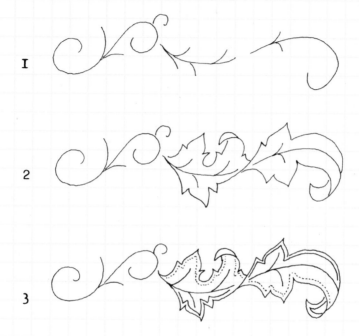

I

2

3

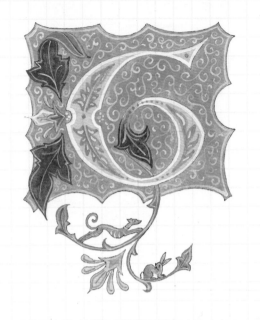

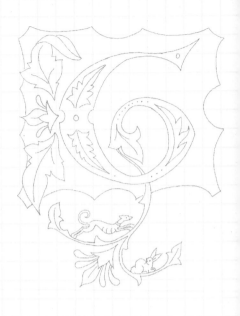

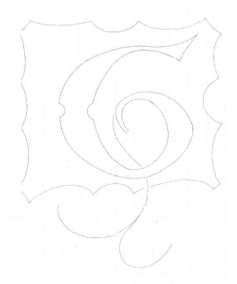

33

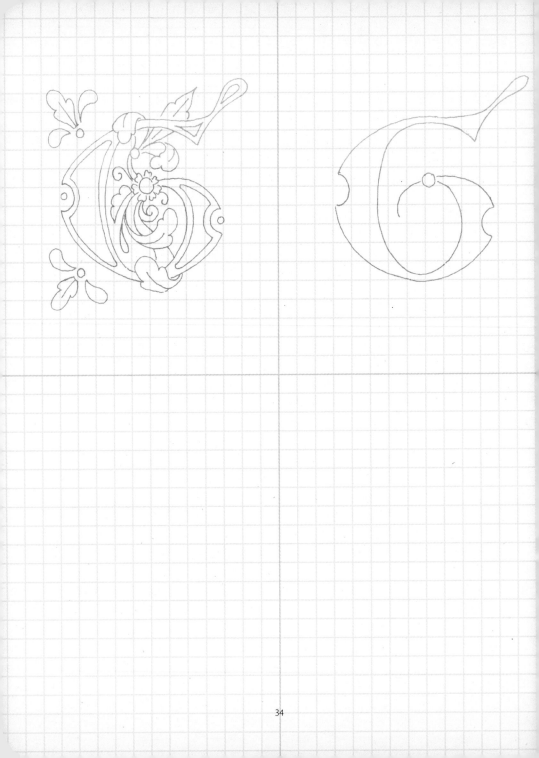

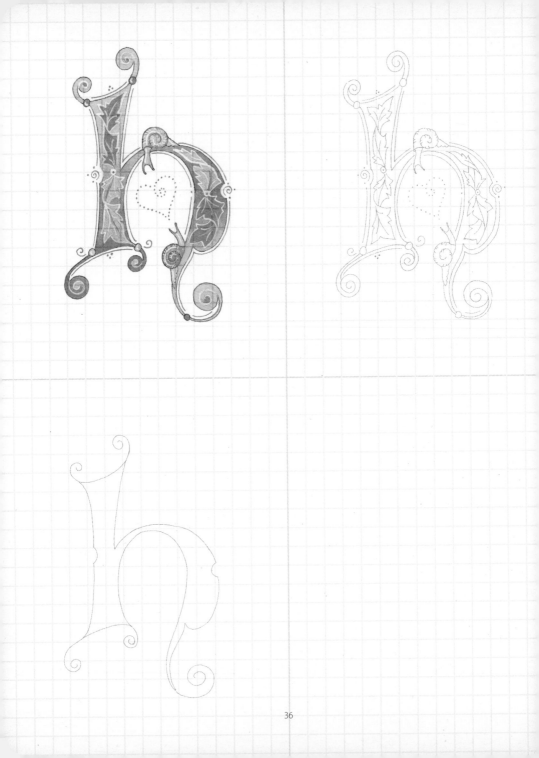

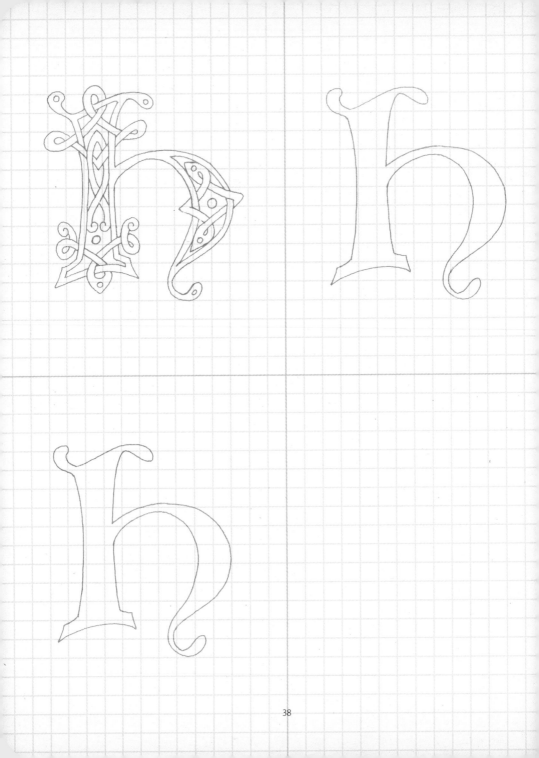

How to Draw Interlacing

The principle of interlaced cords is fundamental to illumination. Imagine the weaving of threads on a loom or the tying of knots: each strand must alternate in an over-under pattern. Using this design concept, the artists of the Middle Ages created masterpieces of densely woven, complicated letterforms and even entire pages of "knotwork" (known in the Celtic tradition as "carpet pages").

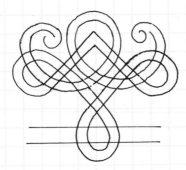
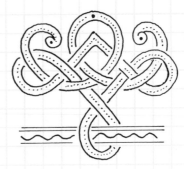

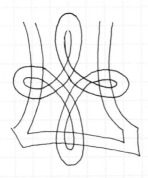
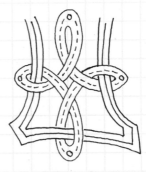

To master this technique, begin by practicing with these models. Trace and fill in the cords below with contrasting colors of gouache, pencil, or marker, respecting the overs-and-unders as you go. When you draw your own interlacing, plan out your designs first in pencil.

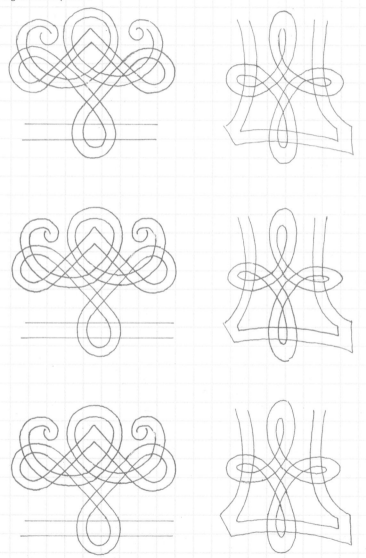

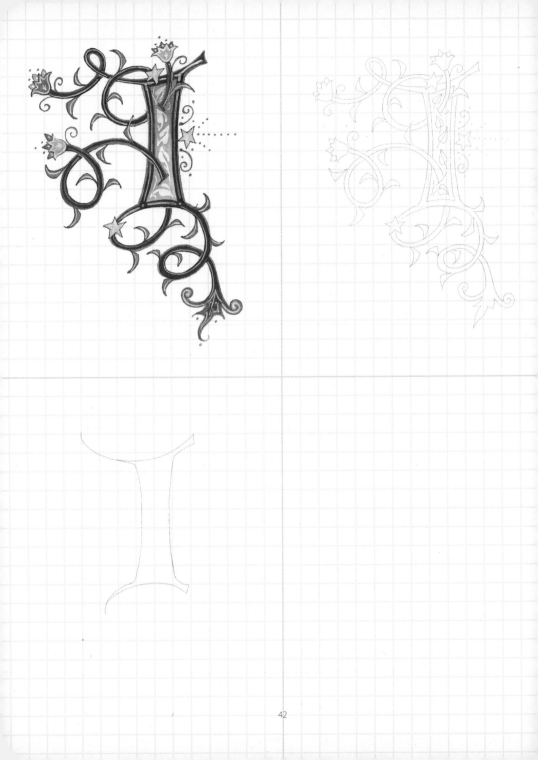

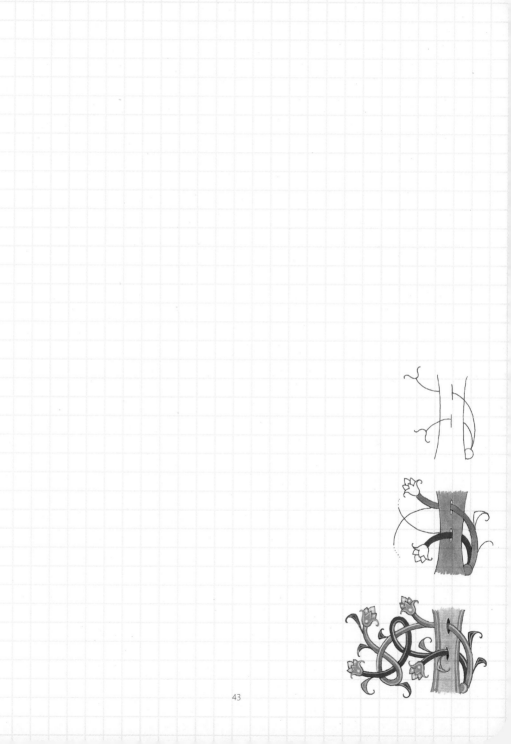

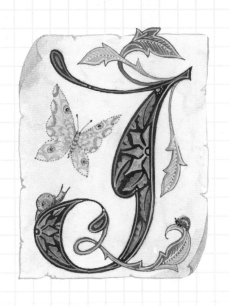

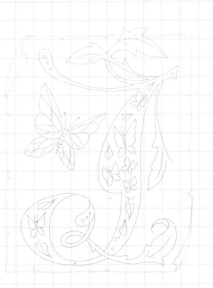

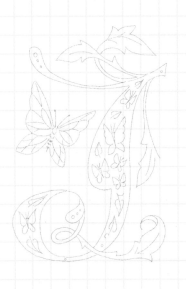

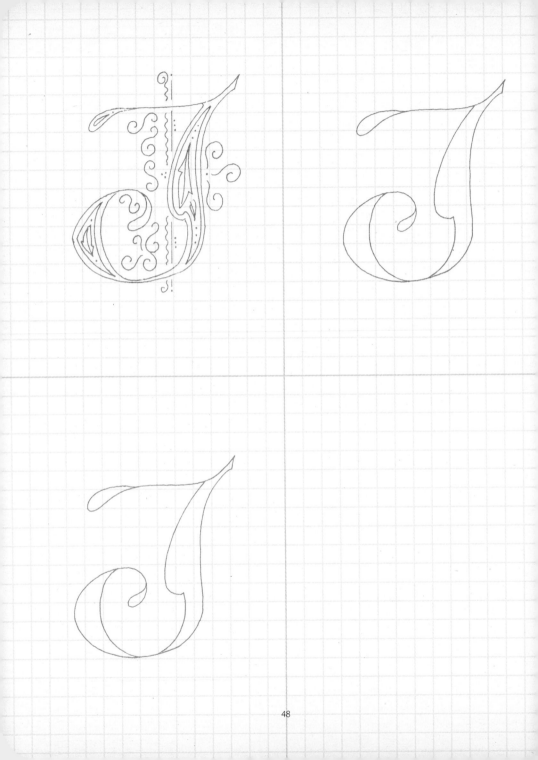

1. Draw the basic outline of your letter in pencil.

2. Allow the letterform to suggest loops and curves which sprout and grow to fill spaces within and around the letter.

3. Transform these lines into cords and add leaves, flowers, or other simple motifs.

4. Re-draw the outline and decoration in ink, respecting the overs-and-unders of forms that intersect with one another. Add any additional designs desired in the body of the letter.

5. Paint the letter in at least two contrasting colors, finishing with highlights in white gouache. (If you're working in colored pencil or marker, instead of creating your white designs on top of the solid background color, sketch them first and leave them blank when you color in the letter.)

1. Begin with the basic form of the medieval letter "T", in pencil.

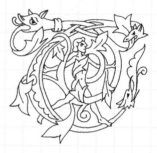

2. Your imagination is completely free to fill the letter with animal heads, twisting leaves, human figures, vines, and cords. The more fantastic, the better! Now retrace the design in ink, establishing the weaving of the cords and leaves in alternating overs and unders.

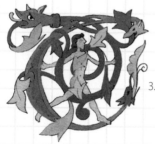

3. Paint the first, solid colors for all parts of the letter, creating a balance of color-changes and harmonious relationships of darks and lights.

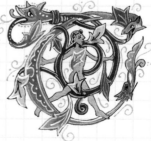

4. With a very fine paintbrush, add darker shadows to some of the lighter colors, and delicate white highlights on all the curves and cords. This is the most privileged moment for the illuminator. The finesse of this work is so absorbing that time seems to stop. The mind is focused and the act of creation gives free rein to the imagination!

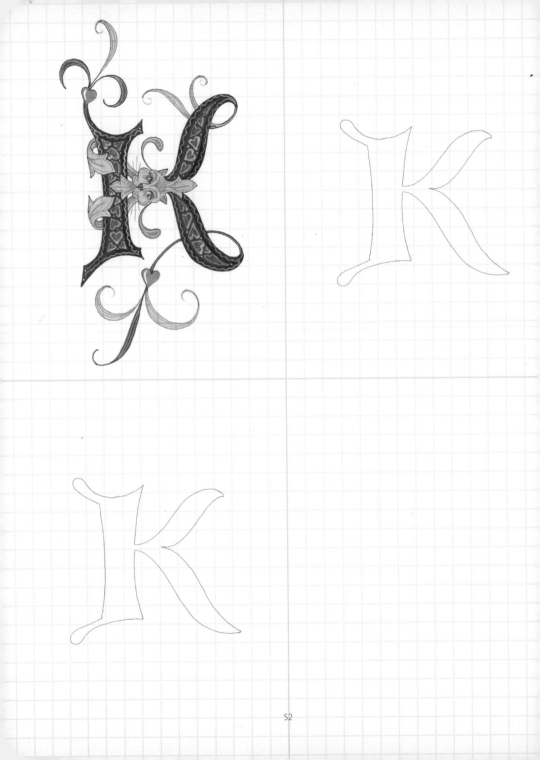

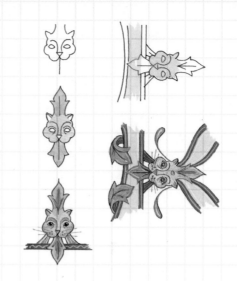

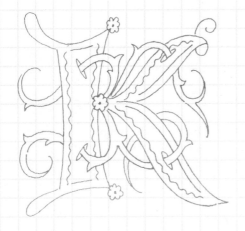

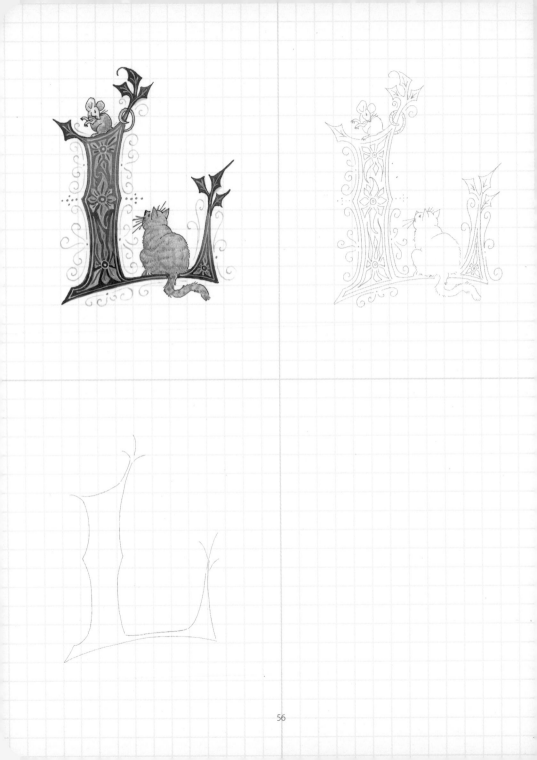

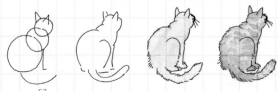

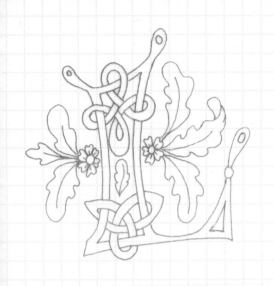

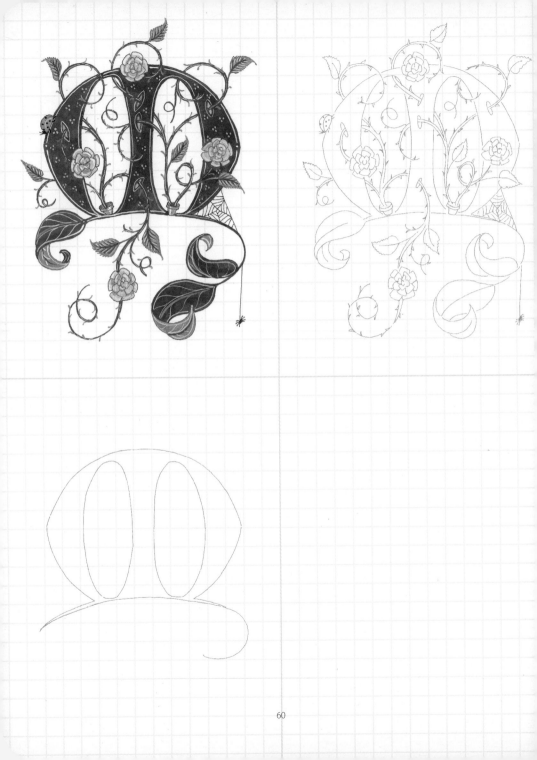

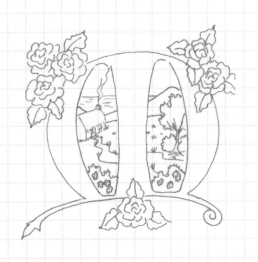

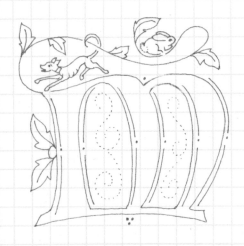

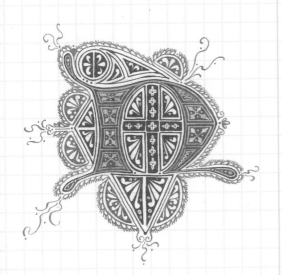

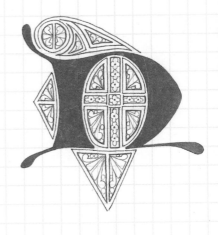

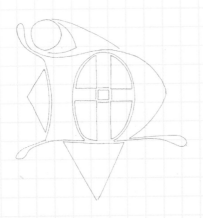

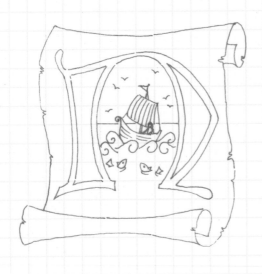

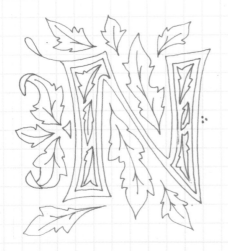

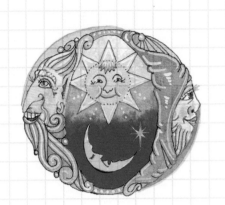

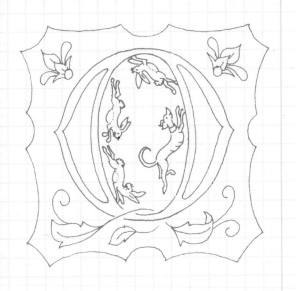

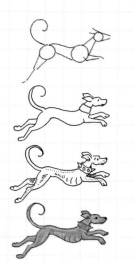

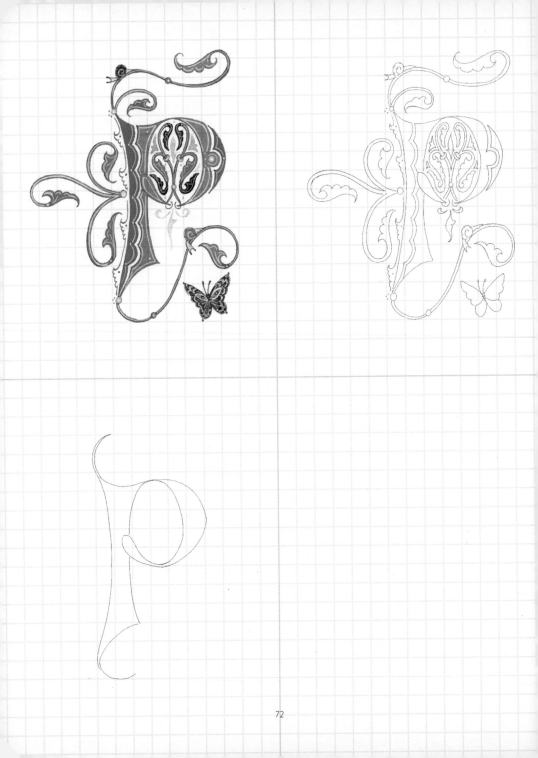

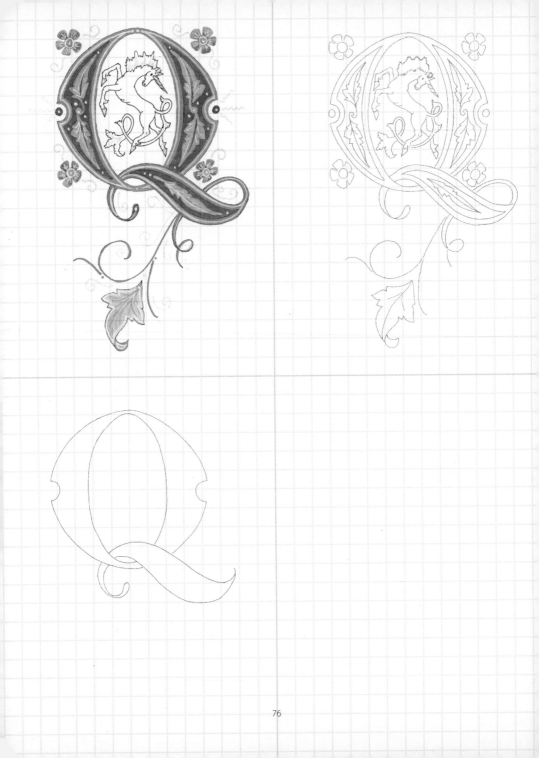

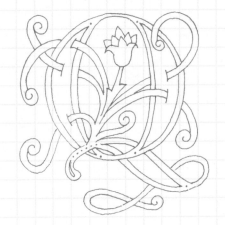

The world of the Celtic illuminator is one of great humor and limitless imagination. The early insular scribes ("insular" referring to the islands of Ireland and Britain) allowed their illuminated initials to become a veritable menagerie of animals tying themselves into contorted knots! Zoomorphic letters like the ones on these pages, from the Irish minuscule tradition of the 7th to 14th centuries, were used to begin verses or paragraphs in poetical texts, prayer books, or collections of heroic legends. Give the principal part of the letter a distinctive color, but leave the minor knotwork in white, so as not to completely lose the form of the letter in a swirling mass of interlace!

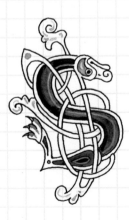

1. Draw the body of the letter in pencil.

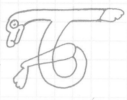

2. Transform the ends of the letter into a head, front paw, and hind leg.

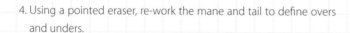

3. With a soft pencil (perhaps a colored pencil), create flowing knots from the mane and tail of the beast.

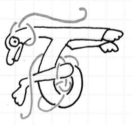

4. Using a pointed eraser, re-work the mane and tail to define overs and unders.

5. In ink, retrace the beast and the knotwork, doubling the lines of the mane and tail.

6. Draw an outline within the body of the animal, and color this in. Don't forget to add the beast's claws!

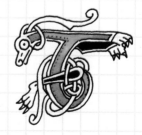

In the Gothic manuscripts of the High Middle Ages, fabulous or grotesque creatures often populate the letters or margins. This scribal style could be compared to the architecture of cathedrals from this epoch, with intricate sculptures of gargoyles or imaginary beasts decorating even the most sacred architecture. One often finds truly amazing and humorous scenes in these illuminations, with roles reversed or mocked: monkeys dressed as bishops, knights jousting with snails, rabbits chasing hunting dogs, or a cheeky bird pulling the tail of a passing deer!

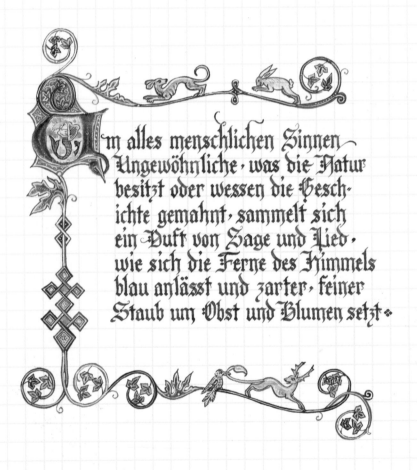

Um alles menschlichen Sinnen Ungewöhnliche, was die Natur besitzt oder wessen die Geschichte gemahnt, sammelt sich ein Duft von Sage und Lied, wie sich die Ferne des Himmels blau anlässt und zarter, feiner Staub um Obst und Blumen setzt.

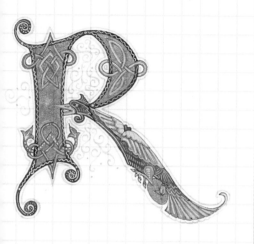

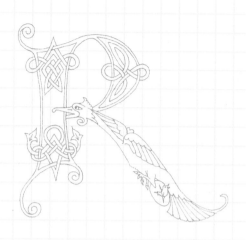

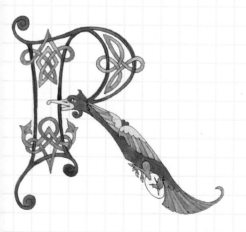

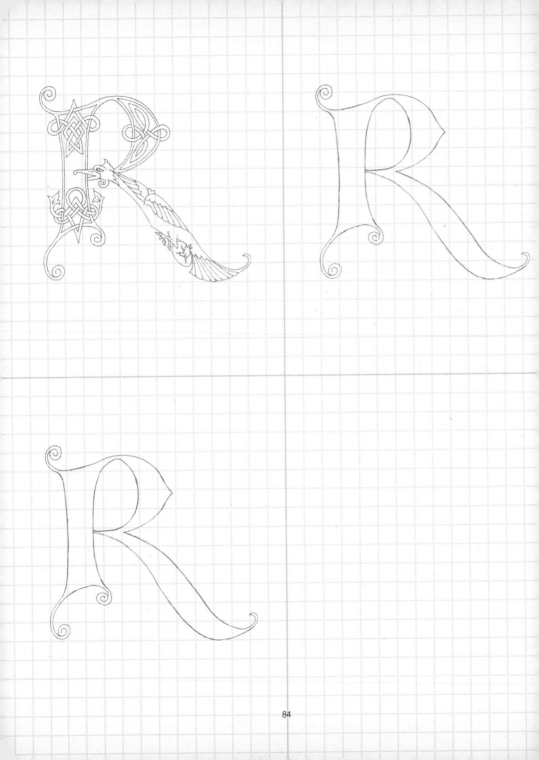

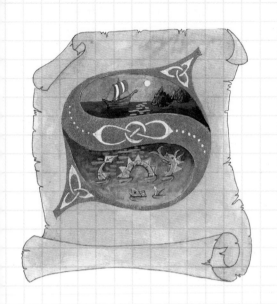

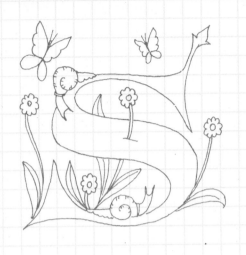

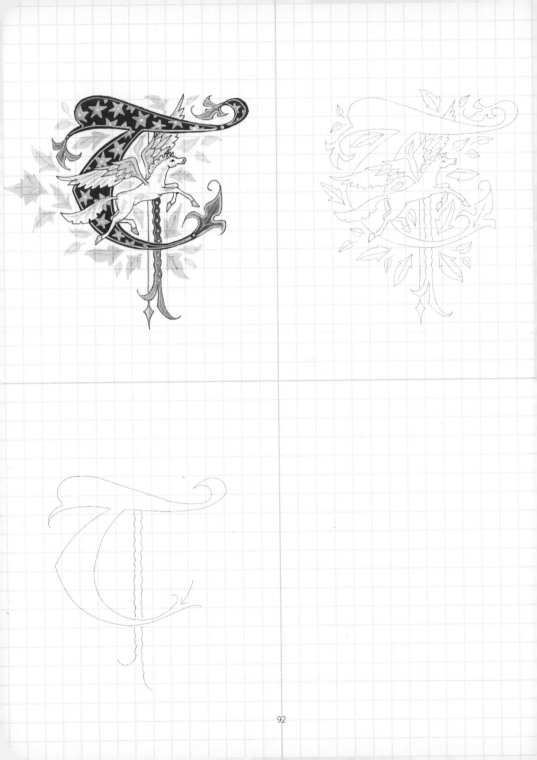

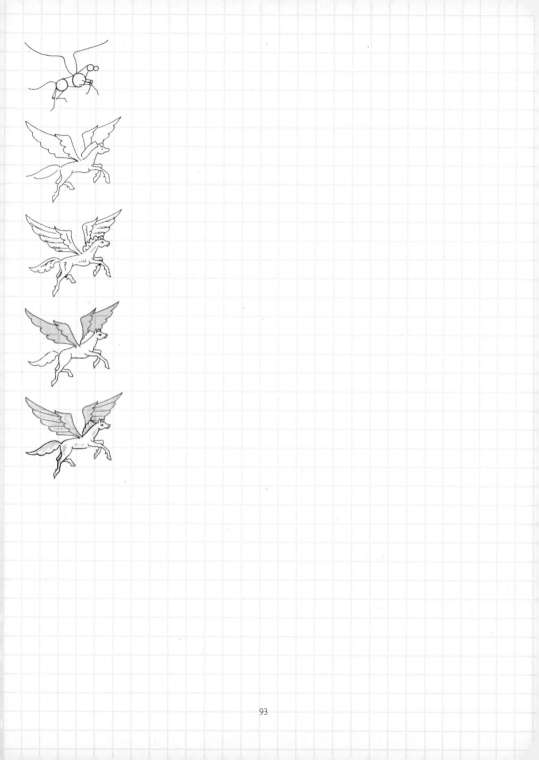

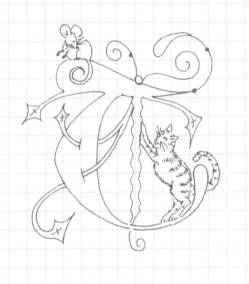

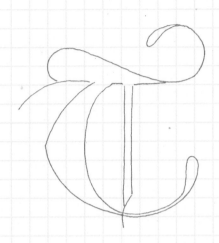

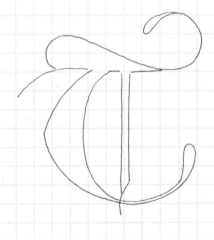

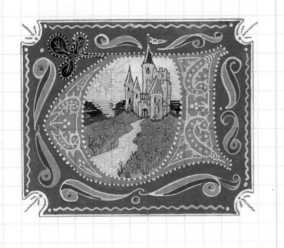

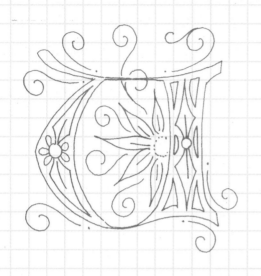

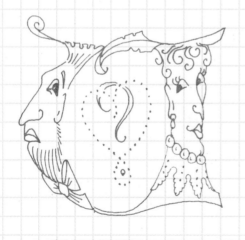

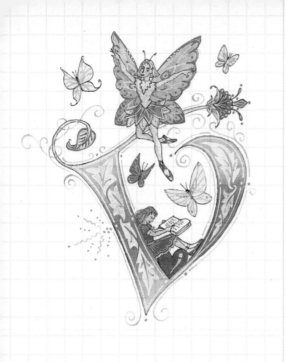

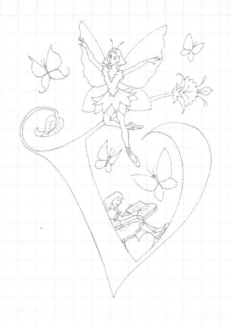

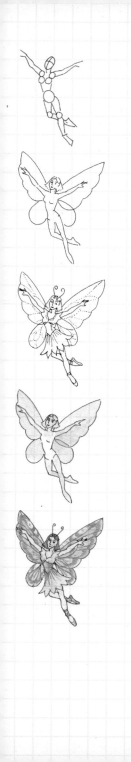

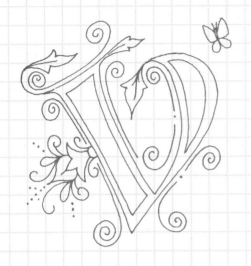

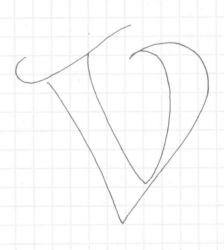

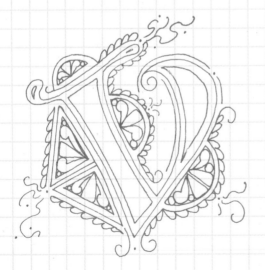

The interlacing of cords to form panels of knotwork has been used in many civilizations, but the Celtic scribes of the Early Middle Ages certainly mastered and clearly delighted in this form of decoration. The principle is simple: every cord must pass in alternating overs and unders with its neighbors.

How to make a knotwork panel:

1. Draw a series of equidistant points: four lines of dots with five dots on each line.

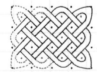

2. In the center of each square formed by four points, make a small red dot. Visualize that each group of two black and two red dots creates a field or space in a diamond shape. (This does NOT need to be drawn, just imagined.)

3. For each diamond-shaped space (two black and two red dots), draw a section of diagonal cord that does NOT touch the dots. All adjacent cords must alternate from right to left diagonals. Do not draw cords where there are only THREE dots.

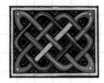

4. On the sides of the panel, where the three-dot spaces occur, fill in arches that connect the cords. At the four corners, the arches should touch the corner-dots to form spatula shapes.

5. The options for coloring these panels are endless. Often the background is filled in with black (which handily covers the dots!). Cords are usually painted in two or more colors, sometimes with highlighted lines that follow the curves in single or double lines.

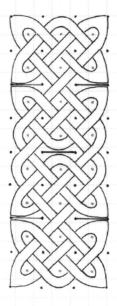

Now... imagine the complications! When you begin with a larger number of dots (any amount is possible), before you draw the diagonals, you can add "walls" as in this example. Whenever your cords arrive at a wall, they must turn to rejoin the next available diagonal.

And another variation: Once the pattern of diagonals is in place, in pencil, treat each intersection as a meeting of FOUR cords, separating the two thick cords into four thinner ones. The overs and unders of these intersections will always be in the same order, so you can draw in the overs and unders of all the intersections in one step, and then continue to separate the remaining cords and curves.

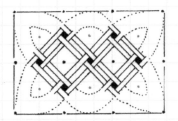

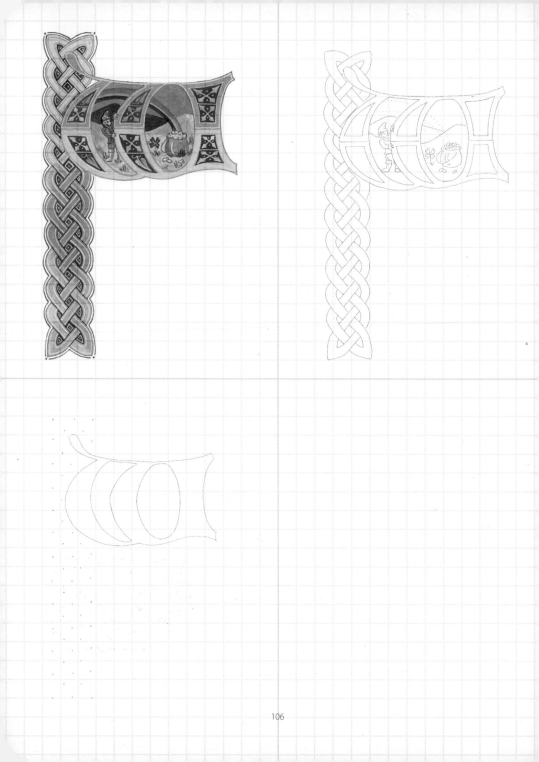

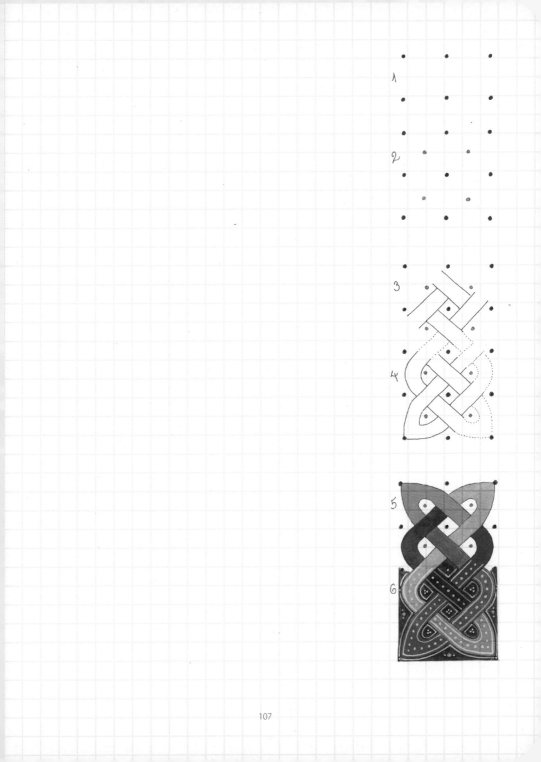

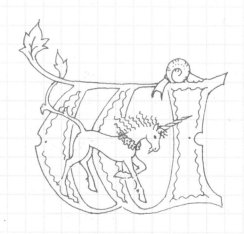

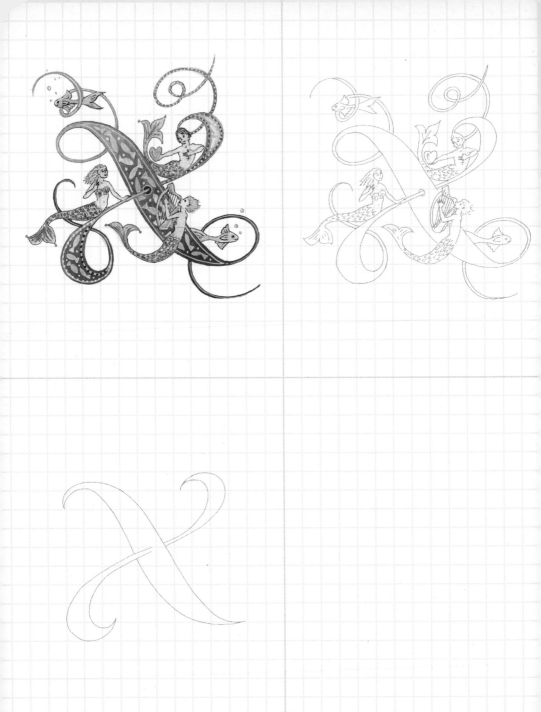

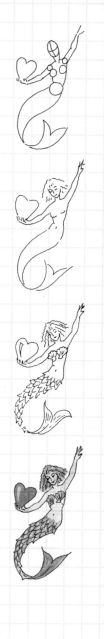

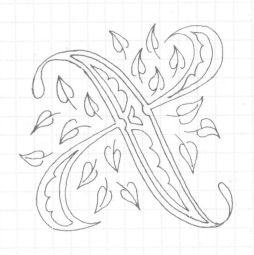
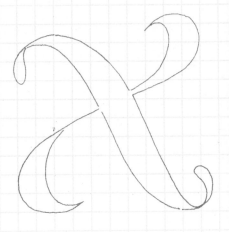
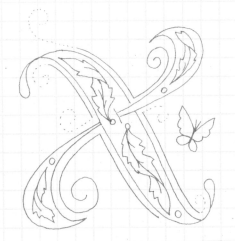

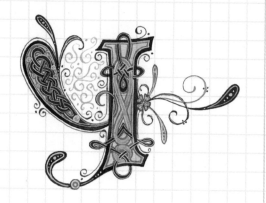

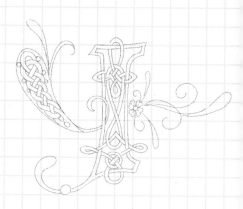

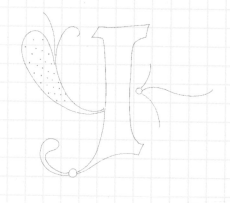

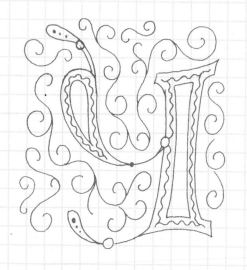

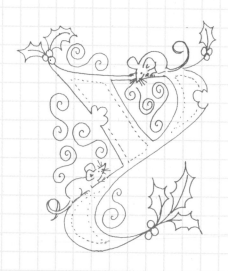

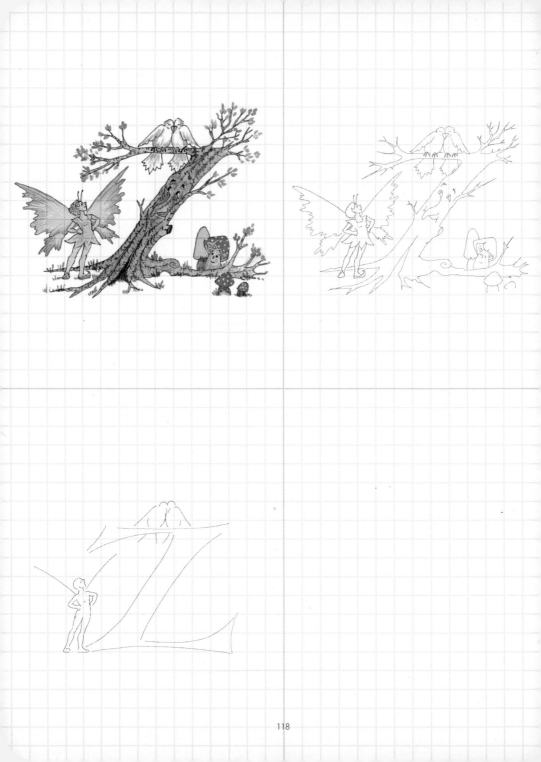

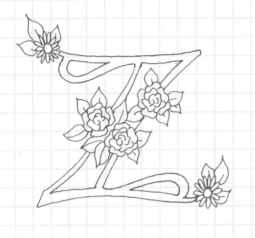

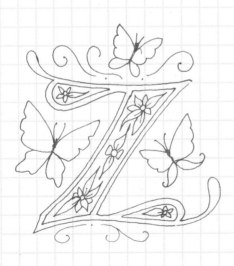

To create a monogram of two or three initials, begin by playing with sketches of the letters in pencil, trying out different relationships between the forms. The letters can remain separate, be on the same line or at different heights, or they can even be interlaced with one another. Remember to respect the rule of "alternating overs and unders." You might begin with simple exercises like the M and S, R and D, or V and P as shown here and on the following pages.

MS

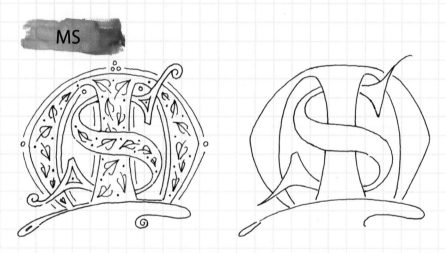

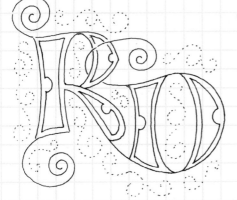 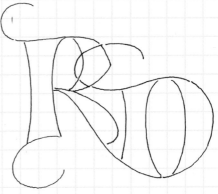

Try yours!

VP

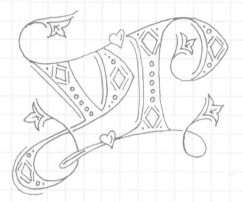

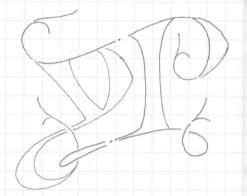

Practice Pages